Joan Miró

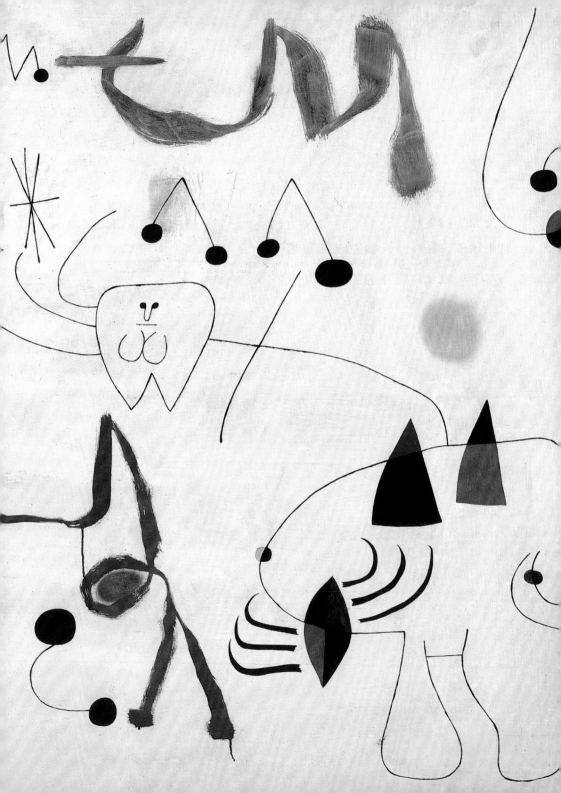

Joan Miró

Iria Candela

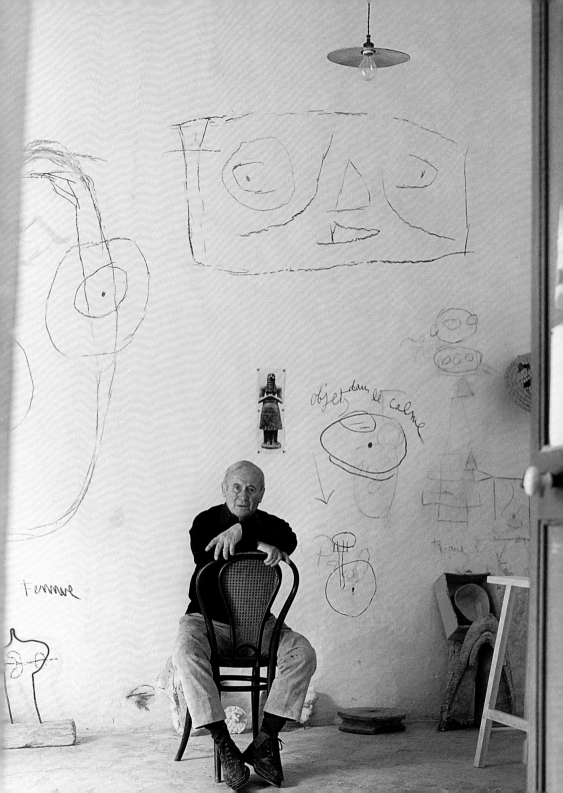

The artist of paradox

In recent years, a common perception of Joan Miró's work has reduced his rich output to a few iconic examples. While this has boosted the popularity of the Catalan artist among global audiences, it has also led to the simplification of a far wider-ranging artistic project. Beyond the apparent simplicity and naivety of his most famous paintings, Miró's oeuvre is the complex result of a multidisciplinary career in constant evolution. It is also the reflection of an ambivalent and enigmatic artistic personality.

In conversation with a French journalist in the late 1960s at his studio in Palma de Mallorca (fig.1), Miró declared: 'I might look calm, but underneath I am tormented'.[1] Indeed, further analysis of his works reveal them to be simultaneously serene and agitated, impulsive and meticulous, dream-like and super-real. These paradoxes within Miró's aesthetic undoubtedly stem from his character and personal history. Interviews and encounters with the artist recorded for film and television also reveal a man who was distant yet kind, silent yet expressive; a zealous guardian of his privacy and, at the same time, a tireless collaborator in collective projects. 'Miró', as his biographer and close friend Jacques Dupin pointed out, 'was at once the most spontaneous and the most constrained of men'.[2]

Early years in Barcelona

Joan Miró i Ferrà was born on 20 April 1893 at number 4 Passatge del Crèdit in Barcelona. His father, Miquel Miró i Adzerias, was a goldsmith and watchmaker, the son of a blacksmith from the Tarragona region, and his mother, Dolors Ferrà i Oromí, was the daughter of a cabinetmaker from Mallorca. A descendant of a family of commercial craftsmen, his father wanted Miró to become a businessman. He attended the Barcelona School of Commerce between 1907 and 1910 and shortly after took a job

as a bookkeeper with an importer of colonial products.

The young Miró, however, had little interest in the business sector. Since childhood he had demonstrated an ability for drawing which, when he turned fourteen, saw him combine his studies with art lessons at the renowned La Llotja School of Fine Arts in Barcelona, where Pablo Picasso had also been trained a few years earlier. Among his teachers there were Modest Urgell and Josep Pascó, who taught him to draw from a sense of touch by giving him objects that he was not allowed to look at. Some of his works from this period of apprenticeship already reveal a remarkable ability to reproduce tiny forms through a profuse variety of colours.

By 1911, tensions with his father had increased owing to Miró's discontent with his current job. 'When I went hunting with him', he would recall years later, 'if I said the sky was purple, he made fun of me, which threw me into a rage'.[3] A nervous breakdown the same year, together with a bout of typhoid fever, eventually persuaded his parents that the young artist was unable to work as an accountant. Miró could not cope with the alienation of the office environment. The art world, however, clearly offered him an escape from the rigid

2. Joan Miró
Portrait of Enric Cristòfol Ricart 1917
Oil and pasted paper on canvas
81.6 × 65.7
Museum of Modern Art, New York

conventions of a bourgeois lifestyle.

During the following three years, he studied at Francesc Galí's Escola d'Art in Barcelona, where he met artists such as José F. Ràfols and Enric C. Ricart, and his future lifelong friends and collaborators Joan Prats and Josep Llorens Artigas. Miró also took life-drawing lessons at the Cercle Artístic de Sant Lluc, founded in Barcelona in 1893 by a progressive group of Catalan artists led by the architect Antoni Gaudí. In fact, Gaudí's organic forms and their free rhythm would later prove to be very influential for Miró, who at the time was also discovering the powerful and expressive images of Catalan Romanesque art and the joyful spontaneity of the popular handicrafts produced on the island of Mallorca.

These early influences nurtured his imagination, as did the series of French paintings that he saw at the 1917 *Exposition d'Art Français* organised by Ambroise Vollard in Barcelona, which included works by Paul Cézanne and Henri Matisse. Actually, most of the works that Miró created before 1918 mimicked the techniques of Post-Impressionism and Fauvism: the landscape *The Path, Siurana* 1917 and *Portrait of Enric Cristòfol Ricart* 1917 (fig.2), for instance, were

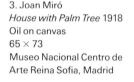

3. Joan Miró
House with Palm Tree 1918
Oil on canvas
65 × 73
Museo Nacional Centro de
Arte Reina Sofia, Madrid

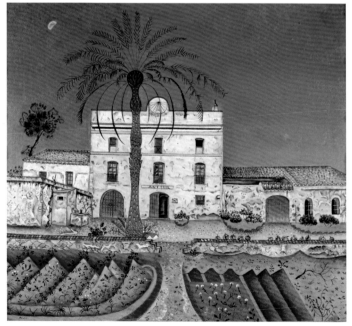

both painted with dense brushstrokes of vibrant colours.[4] However, the public presentation of such works proved a complete failure; at his first solo show, organised by the art dealer Josep Dalmau in Barcelona in February 1918, Miró sold none of his paintings and the reactions of the public and the critics were very hostile – to such an extent that a few works were defaced.

These adverse responses probably prompted Miró to create a new painting style. From July to December 1918, inspired by the landscape of Mont-roig del Camp – the Tarragona village where his family had acquired a *masía* (farm) – he painted four works with meticulous attention to detail. One of them, *House with Palm Tree* (fig.3), showed the artist's exhaustive efforts to capture even the most insignificant elements of the house and its garden, which were reproduced using a miniaturist technique.

Together with his interest in detail, Miró developed an original artistic approach defined by a disregard for the hierarchical representation of natural scenes. In August 1918, he wrote to Ràfols: 'Joy at learning to understand a tiny blade of grass in a landscape. Why belittle it? A blade of grass is as enchanting as a tree or a mountain'.[5] The 1919 painting *Mont-roig, the Church and the Village* (fig.22) demonstrates how, as part of a gradual process of disdaining realist techniques (still prevalent in the upper section of the canvas), Miró achieved a schematic composition where the traditional perspective gives way to a stylised representation of furrows and ears (as seen in the lower half).

Miró's 1919 *Self-Portrait* (fig.21) is also characterised by a new style that broke with the constraints of realism. In this work, he is not concerned with a detailed reproduction of the features of his own face, but rather with capturing his inner, enigmatic self. The two-dimensional and static frontality of the figure, together with the sharp pleats of his red jacket, emulate the transcendental style of the representation of Christian deities in Catalan Romanesque frescoes – in particular those at the Sant Climent de Taüll church.

While searching for a personal style, Miró became familiar with the artistic experiments of the European avant-garde movements. He read Guillaume Apollinaire's collection of poems, *Calligrammes*, and, through Dalmau, met artists Robert Delaunay and Francis Picabia. Miró's contact with the French artists confirmed his rejection of the

dominant, regressive art world of Barcelona. It was evident that if he wanted to establish links with the art of his time he had to go to Paris. As he noted to Ricart in September 1919, 'I should a thousand times prefer – I really mean it – to be an utter failure, to fail *miserably* in Paris, to being a big frog in the stagnant pond of Barcelona'.[6]

Between Paris and Mont-roig: *The Farm*
On his first trip to Paris in Spring 1920, Miró visited the Musée du Louvre, attended the Dada Festival at the Salle Gaveau and met several artists (such as Picasso, who immediately appreciated Miró's early paintings and even purchased his 1919 *Self-Portrait*). In May, Miró wrote: 'This Paris has *shaken me up* completely. *Positively*, I feel kissed, like on raw flesh, by all the sweetness here'.[7] His appreciation of the city lasted for life; in fact, over the following fifteen years Miró divided his time between the Parisian cosmopolitan atmosphere and Mont-roig's rural environment. The city offered him a much-needed intellectual stimulus, as well as the prospect of socialising and promoting his work; in contrast, the farm provided the perfect isolation for artistic production.[8]

In March 1921, Miró rented the Paris studio of the Spanish sculptor Pablo Gargallo, who also divided his time between France and Catalonia. It was there, at 45 rue Blomet, that Miró met the Surrealist artist André Masson, who lived and worked in the studio next door and who introduced him to artists and writers, such as Antonin Artaud, Robert Desnos, Michel Leiris and Roland Tual. Through active contact with this group Miró discovered French poetry, reading work by Comte de Lautréamont, Arthur Rimbaud and Alfred Jarry. In May, he held his first solo exhibition in Paris, organised by Dalmau for the Galerie La Licorne. Despite not selling any work, a small catalogue was published with a preface by the important French art critic Maurice Raynal. In a text written many years later, Miró declared: 'The Rue Blomet was a decisive place, a decisive moment for me. It was there that I discovered everything I am, everything I would become'.[9]

In summer 1921, Miró was back in Mont-roig. He began to paint *The Farm* (fig.23), a picture of the *masía* that would both consolidate his previous work and anticipate his later evolution. He maintained a 'detailist' style, which allowed him to faithfully replicate the

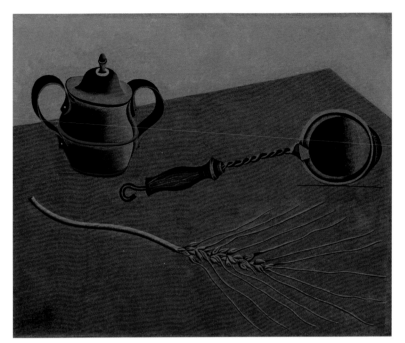

4. Joan Miró
Still Life I 1922–3
Oil on canvas
38 × 46
Museum of Modern Art,
New York

architectural and natural environment of the farm: alongside the
eucalyptus that dominates the centre of the composition, we find
the house, the coop and the water tank, as well as a donkey, a goat,
a lizard and a snail. At the same time, geometric and symbolic figures
undermine the naturalistic representation: the dominant black circle
around the base of the tree trunk, the mysterious footprints on the
path and the squatting little man-insect behind the farmer woman,
all look forward to the painter's later incursion into surreal imagery.[10]

While painting *The Farm*, Miró also produced a series of still-
life works with the aim of getting beyond the realistic techniques
of composition. In *Still Life I* 1922–3 (fig.4), the table is drawn in
perspective, while the jug, the sieve and the ear of grain, which we
might expect to be supported by the table, float freely in a space
that is about to lose its depth of field completely. It was immediately
after this that Miró came to understand the canvas as a 'magnetic
field' activated by an 'electric current',[11] and where the laws of gravity
can be truly challenged – as seen in *Maternity* 1924 (fig.5), painted
the following year in which the most crucial change of Miró's career
would occur.

5. Joan Miró
Maternity 1924
Oil on canvas
92.1 × 73.1
Scottish National Gallery
of Modern Art, Edinburgh

Annus mirabilis

The development of Miró's style during 1924 was the result of his obstinate refusal to succumb to his difficult financial situation. 'During this period', he would later remember, 'hunger gave me hallucinations and the hallucinations gave me ideas for paintings'.[12] Among these ideas, the major one consisted of transforming the canvas into a neutral, indeterminate surface where figures could float free as dream-like signs within a transfigured world.

The three most important pieces demonstrating Miró's achievements in pictorial freedom were *The Tilled Field* 1923–4, *Catalan Landscape (The Hunter)* 1923–4 and *Harlequin's Carnival* 1924–5. In these, the artist relinquished the creation of space through illusions of volume and perspective. His new discovery allowed him to transcend the main spatial metamorphosis of Cubism: he no longer felt the need to follow the rules for representing three-dimensional objects from multiple points of view, because there was no such thing as three-dimensional in *his* world. This was a fundamental transformation and one that would have a great impact on twentieth-century abstract painting.[13] Miró himself

was probably aware of his achievement when, in autumn 1923, he wrote: 'Hard at work and full of enthusiasm … *All the pictorial problems resolved*'.[14]

The Tilled Field (fig.24) still pays attention to detail as *The Farm* did, but its connection to the site of Mont-roig is now dominated by the rhetoric of dreams. The tree trunk grows an ear while an eye and a giant pine cone emerge from its branches. The snail and the hare appear surrounded by strange animals, reminiscent of those in the Hieronymus Bosch triptychs. *Catalan Landscape (The Hunter)* (fig.25) also merges the imaginary and the real. Miró presents the Catalan peasant with his knife and rifle, smoking a pipe, standing above a sardine with whiskers and a single rabbit's ear. Both fish and hunter are signs rather than bodies. The tree is just a sphere with a single leaf, and the hunter's head a triangle with a Catalan beret and beard. Geometrical forms reappear in *Harlequin's Carnival* (fig.26), where a blue and red circle with moustache and sad eyes observes a scenario full of characters of fantasy: two cats, disguised as harlequins, play with a ball of wool; an insect emerges from a dice; musical notes flow out from a little guitar.

It has often been noted that the profound transformation undergone by Miró's work in 1924 was due to his contact with Surrealism. Indeed, that year the artist started to attend meetings organised by André Breton, Louis Aragon and Paul Eluard, prominent figures of the Surrealist movement, which Miró joined right after its official founding with the publication of Breton's first *Manifeste du surréalisme* in October 1924.[15] Nonetheless, according to Dupin, Miró owed the discovery of a new pictorial style to his *own* artistic talent despite the fact that 'the change was so profound, so radical and apparently so sudden that it seemed reasonable to look for external causes to explain it – as if Miró could only have been struck, converted and illuminated by some force outside himself'.[16]

The reality of the *fantastique*

In June 1925, Miró presented his new paintings in a solo exhibition organised by Jacques Viot at the Galerie Pierre in Paris. The exhibition's invitation was signed by several members of the Surrealist group, including Masson, Leiris, Eluard, Aragon and Breton. In November that year, the legendary group show *La Peinture surréaliste* took place at the same gallery, including works by Max Ernst, Hans Arp, Giorgio

de Chirico, Paul Klee, Man Ray, Masson and Miró, who showed *Harlequin's Carnival* and two other paintings.

By this time Miró had blended the realms of reality and illusion within the same pictorial space, once and for all freed from figurative conventions. Such a fantastic universe was intended to produce in the viewer an experience of visual shock: 'A deepening sense of the marvellous led me to the notion of the fantastic', Miró would later declare. 'I was no longer subjected to a dream-dictation, I created my dreams through my paintings'.[17] Two of these dream-like paintings made in 1925 demonstrate the artist's overcoming of the calligraphic technique of his previous works, turning the canvas into an astral field where a diverse range of accidents occurs: *The Red Spot* (fig.28) presents an amorphous floating red mass violently pierced by sharp black needles, while *The Birth of the World* (fig.27) scatters blue lines and red and white circles over a greyish background.

For Miró and the Surrealists, the notions of 'mystery' or 'fantasy' had no religious or metaphysical meanings. The secular character of the concept was already emphasised in Breton's *Manifeste*, where he wrote: 'What is admirable about the fantastic is that

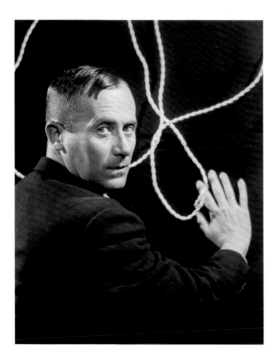

6. Man Ray
Portrait of Joan Miró 1930
Silver gelatin print
Man Ray Trust

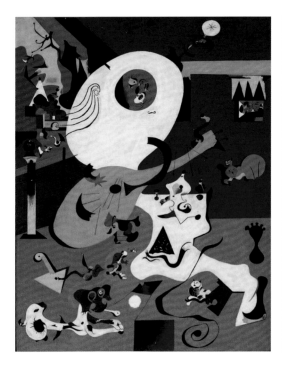

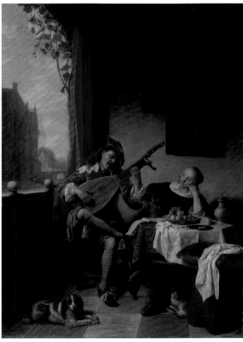

there is no longer anything fantastic: there is only the real'.[18] Miró always maintained that his paintings were not abstractions but images strongly anchored in the reality of human experience, which of course includes the realm of the subconscious. In a 1937 interview, he pointed out: 'I cannot understand – and consider it an insult – to be placed in the category of "abstract painters"... As if the marks I put on a canvas did not correspond to a concrete representation of my mind, did not possess a profound reality, were not a part of the real itself!'.[19]

In May 1928, the art dealer Pierre Loeb organised a Miró exhibition at the Galerie Bernheim in Paris that proved both a commercial and critical success; it was the same year in which Breton wrote that Miró 'may be considered the most surrealist among us'.[20] His 'painting-poems', which combine painted and written elements, also date from this period. Miró created these from his experiments with the idea of materialist fantasy. This particular series of works incorporated the writing of poetic verses emulating the Surrealist practice of *écriture automatique* (automatic writing), in which a word

7. Joan Miró
Dutch Interior I 1928
Oil on canvas
91.8 × 73
Museum of Modern Art,
New York

8. Hendrik Martensz Sorgh
The Lute Player 1661
Oil on panel
52 × 39
Rijksmuseum, Amsterdam

9. Joan Miró
Final Study for Dutch Interior I 1928
Charcoal and pencil on paper
62.6 × 47.3
Museum of Modern Art, New York

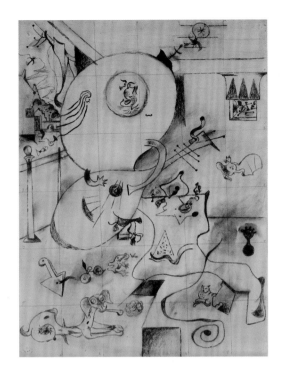

could trigger another with no attempt at coherence or sequential logic. *Photo: ceci est la couleur de mes rêves* 1925 (fig.33) and *Un Oiseau poursuit une abeille et la baisse* 1927 (fig.34) not only present the canvas as a surface for poetic verse, but also reveal Miró's ability to 'extract from each form the sign latent within it, to unshackle the sign from the matrix of realistic representation'.[21]

At the end of 1928, Miró started a series of works inspired by the Flemish pictures he had just seen on a short trip to the Netherlands. *Dutch Interior I* 1928 (fig.7), for instance, is his version of Hendrik Martensz Sorgh's seventeenth-century masterwork *The Lute Player* 1661 (fig.8). Although his reinterpretation proved to be radical, Miró kept some elements of the original painting, such as the lute and the dog, and studied Sorgh's composition with utmost attention – as seen in previous sketch drawings (fig.9). The works in this series were not unintentional deconstructions of classical paintings but rather meticulous processes of working through original compositions, which served the artist's aim to produce a purely Mironian vision.[22]

It was during these years that Miró became acquainted with

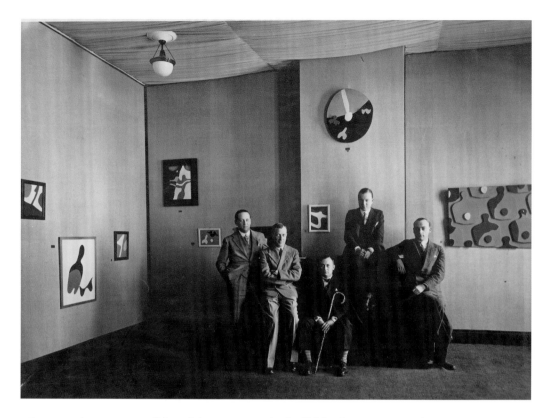

other prominent personalities of the avant-garde. In 1926, after moving to a new studio at 22 Rue Tourlaque, the artist met two of his neighbours, the former Dadaists Max Ernst and Hans Arp. Miró collaborated with Ernst on the set design of *Romeo and Juliet*, which was commissioned by the Ballet Russes impresario Sergei Diaghilev and premiered in Monte Carlo in 1926.[23] In 1928, he visited Arp in Brussels, where his exhibition of biomorphic paintings at the Galerie l'époque (fig.10) made a big impression on the Catalan artist. At the end of that year, Miró met Alexander Calder, whom he invited to present his prodigious *Cirque* 1926–7 in Barcelona and Mont-roig and with whom he would later team up on several public projects, resulting in a long-lasting friendship.[24] In 1929, Miró made the acquaintance of Luis Buñuel and Salvador Dalí; on the occasion of the 1930 Paris premiere of their Surrealist film *L'Age d'or*, he exhibited several works at Studio 28, which were attacked by right-wing extremists during one of the screenings.

10. View of Jean Arp exhibition at the Galerie l'époque, Brussels, 1928 Silver gelatin print Archives de l'Art contemporain en Belgique, Musées royaux des Beaux-Arts de Belgique, Brussels

11. Raoul Barba
Jeux d'enfants:
Joan Miró
painting the curtain, 1932
Silver gelatin print
Fundació Joan Miró,
Barcelona

The assassination of painting

Married since October 1929 to Pilar Juncosa (their only child, Dolores, was born in July 1930), Miró settled in a new apartment in Paris and continued to show his paintings both in France and internationally: exhibitions of his works were held in Brussels (1929); Chicago (1931); Prague and Berlin (1932); London (1933); and Zurich (1934) among others. From 1932 onwards, he was represented in New York by the renowned art dealer Pierre Matisse. The same year, he received a commission from Léonide Massine to design the costumes, props, set and stage curtain (fig.11) for another Ballet Russes production, *Jeux d'enfants*, which premiered, with music by Georges Bizet, at the Grand Théâtre of Monte Carlo (fig.12).

By 1928, Miró had already started to examine alternative methods of artistic production through the techniques of collage and assemblage. Far from understanding art 'as an end in itself',[25] he aimed to overcome the limitations of easel painting and attempted this in a daring and visceral way, as epitomised by his illustrious sentence

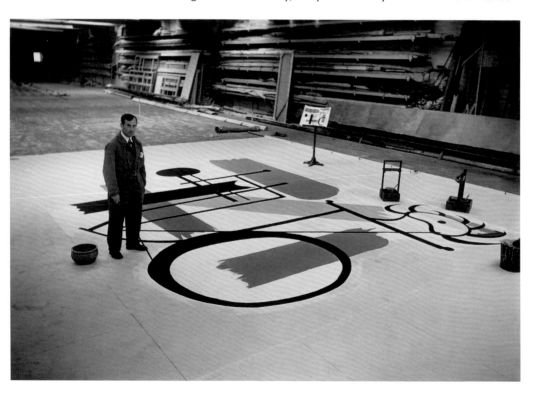

17

12. Roaul Barba
Jeux d'enfants: the hobby-
horses, scene IV, 1932
Silver gelatin print
Fundació Joan Miró,
Barcelona

'Je veux assassiner la peinture' ('I want to assasinate painting').[26]
An elegant collage-object, *Portrait of a Dancer* 1928 (fig.36), consisted
simply of a feather, a cork and a hat-pin fixed on a canvas. Two 1930
assemblages, *Construction* (fig.37) and *Relief Construction* (fig.38),
were made with wood panels, staples and oil-painted nails. In other
mixed-media pieces from the early 1930s, Miró used tinfoil, sand,
wire or rope, as can be seen in his expressive *Rope and People, I* 1935
(fig.40).[27] The introduction of new materials subverted the traditional
practice of painting and was the result of what curator Anne Umland
has described as 'the troubling malaise and sense of creeping doom
that was spreading throughout Europe as the so-called Roaring
Twenties came to an end and as the political tensions that would,
by 1939, lead to the Second World War became increasingly real
and physically felt'.[28]

Aidez l'Espagne

Between 1934 and 1936, Miró created a series of oil and pastel
'savage paintings', as he called them, dominated by cruel and
violent subjects. These works anticipated the particularly distressing
paintings he would go on to make during the years of the Spanish Civil
War (1936–9). In a letter to Pierre Matisse dated 12 January 1937, Miró
wrote: 'We are living through a terrible drama, everything happening

in Spain is terrifying in a way you could never imagine'.[29] Out of such dramatic feelings emerged *Still Life with Old Shoe* 1937 (fig.41), a significant painting through which Miró returned to 'realism' as a way to express these newly acquired emotions of anguish and despair. The painting shows, as the artist himself described, an empty gin bottle wrapped in a piece of paper with string around it, a large dessert apple pierced by a fork, a crust of black bread and an old shoe.[30] The six prongs of the fork, the use of bright and dissonant colours and the powerful presence of the shoe (reminiscent of Vincent van Gogh's renowned shoe paintings), all add a poignant strength to the composition. Years later, the Catalan artist would affirm: 'The civil war was all bombings, deaths, firing squads, and I wanted to depict this very dramatic and sad time. I must confess that I wasn't aware that I was painting my *Guernica*'.[31]

In the same spirit of response to the unfolding of events in his native country, in 1938 Miró completed *Self-Portrait* (fig.42) and *Head of a Woman* (fig.43). He depicted his stunned face dissolving in a universe of stars and flames; whereas in his adaptation of the *mater dolorosa*, he combined dramatic pathos with hallucination in the visionary image of a woman raising her hands towards the sky.

Although Miró had never taken an active part in politics, during the Spanish Civil War he was determined to join the cause against fascism and collaborate with the Republican government.[32] Firstly, he participated in the Spanish Republican Pavilion at the 1937 Paris World Exhibition.[33] Together with other emblematic works exhibited in the building designed by architects Josep Lluís Sert and Luis Lacasa – such as Picasso's *Guernica* 1937 and Calder's *Mercury Fountain* 1937 (fig.13) – Miró produced *in situ* a five-metre high mural titled *The Reaper* or *Catalan Peasant in Revolt* (fig.14). Its main character was a harvester armed with a sickle – a figure that directly alluded to *Els segadors* (*The Reapers*), the anthem of Catalonia.[34]

Secondly, Miró designed a one-franc stamp with the purpose of raising money for the Republican cause. *Aidez l'Espagne* (*Help Spain*) 1937 (fig.39) was published as a *pochoir* in a 1937 issue of the journal *Cahiers d'art*. His design pictured a peasant raising his fist, a symbol, like the reaper, of the struggle for freedom in Spain. Below the image, Miró wrote and signed the following annotation: 'In the current struggle I see the outdated forces of fascism on one side and,

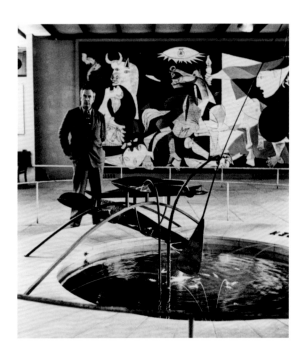

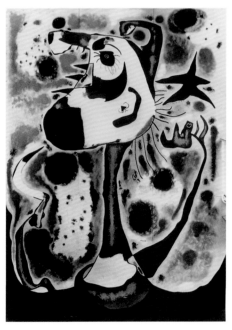

on the other, those of the people, whose immense creative resources will give Spain a drive that will amaze the whole world'. Despite Miró's encouraging pleas, the Nationalist Army of General Franco won the war in 1939, imposing a fascist dictatorship that lasted until 1975.

Constellations in internal exile

In August 1939, right before the start of the Second World War, Miró and his family moved from Paris to Varengeville-sur-Mer, in Normandy, where he began a series of gouaches titled *Constellations*. These were twenty-three small-format works, minutely detailed, in which Miró's command of colour and signs-composition attained full maturity. *Nocturne* 1940 (fig.45) and *Woman in the Night* 1940 (fig.46), for instance, present striking scenes, with sexual undertones, which although barely 38 by 46 centimetres in size, give the impression of modern and 'large frescoes'.[35]

When the German army invaded France in May 1940, Miró was forced to move back to post-civil war Spain. Fearing political repression and advised by his friend Joan Prats, he decided to stay away from Barcelona and settle on the secluded island of Mallorca,

13. Hugo P. Herdeg
Alexander Calder's *Mercury Fountain* and Pablo Picasso's *Guernica* at the Spanish Republican Pavilion, Paris World Exhibition, 1937
Silver gelatin print
Calder Foundation New York

14. Joan Miró's *The Reaper* at the Spanish Republican Pavilion, Paris World Exhibition, 1937

where he would spend two years of 'interior exile', working in reclusion, and devoting time to reading the Spanish sixteenth-century mystical poets and to listening to the music of Johann Sebastian Bach and Wolfgang Amadeus Mozart.

In 1942, Miró relocated to Barcelona, a city now plunged into post-war economic and cultural poverty, where he would spend the next fifteen years. In 1944, commissioned by Prats, Miró made the *Barcelona* suite, a set of fifty lithographs of which only seven copies were printed (fig.15). Renouncing colour, the artist evoked the atrocities of war through deformed figures that paradoxically inhabited a 'cosmos of erotic symbolism'.[36] The American critic Clement Greenberg referred to that combination of terrible and comic elements as 'post-war hedonism', noting that Miró provided 'amusement through the fearful'.[37]

Although in Spain Miró worked in privacy or with the support of a few friends, his oeuvre was starting to achieve international acclaim. A first retrospective took place at the Museum of Modern Art (MoMA) in New York in 1941 and two books about his work were published (the monographs written by the Japanese Surrealist Shuzo Takiguchi and by American curator James Johnson Sweeney).[38] This recognition encouraged the artist to both extend his practice to new formats – such as sculpture, mural painting and ceramics – and to travel for the first time to the United States in 1947.

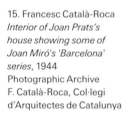

15. Francesc Català-Roca
Interior of Joan Prats's house showing some of Joan Miró's 'Barcelona' series, 1944
Photographic Archive F. Català-Roca, Col·legi d'Arquitectes de Catalunya

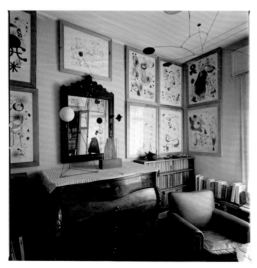

International recognition

In December 1946, Miró received a commission for a mural painting in
the Gourmet Restaurant at the new Terrace Plaza Hotel in Cincinnati,
Ohio. In February 1947, he flew to New York to paint the mural (fig.48)
in the studio of Carl Holty. While at work, Miró was photographed
by Arnold Newman and filmed by Thomas Bouchard, who later
included the footage in his 1955 documentary *Around and About
Joan Miró*. Before its final installation in Cincinnati (fig.16), the mural
was exhibited at MoMA in March 1948. It is important to note that
Miró had conceived a site-specific work with the intention of fulfilling
a social purpose. Instead of filling the entire surface of the painting,
he created focal points with violent colours and autonomous figures.
As his friend Sert once declared, 'this kind of painting can give great
life and animation to architectural spaces, providing points of tension
and visual accents. It can work with the architecture of today and not
against it'.[39]

Indeed, Miró did not understand the mural as a decorative work of
large dimensions, but rather as an expansive, frameless painting that
interacted with the architectural space for the users' enjoyment. In a
letter written after the completion of the mural, he said: 'Easel painting
is only good as a form of relaxation and to achieve poetry – and that
is valuable in itself – but what we must pursue is a broad human
and collective scope'.[40] It was after the war that Miró particularly

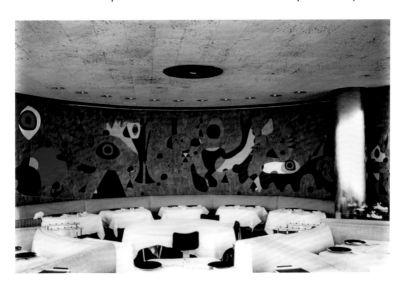

developed his humanist conception of art. Thus he remained loyal to the ultimate motivation of the 1920s Surrealist spirit: to attack the dominant bourgeois values with a new morality, based upon poetry, freedom and, most of all, common welfare. 'The artist is a man who must go beyond the individualistic stage and struggle to reach the collective stage', he once stated. 'He must go further than the self – strip himself of his individuality, leave it behind, reject it – and plunge into anonymity'.[41]

During his nine-month stay in New York, Miró also worked at Atelier 17, where he perfected his knowledge of printing techniques and where he met American artist Jackson Pollock. From that moment on, a two-way dialogue would be established between Mironian art and Abstract Expressionism: painters such as Arshile Gorky, Willem de Kooning and Pollock were influenced by the Catalan artist and Miró welcomed with enthusiasm the stylistic influences of the American painters – as seems evident in *Solitude II* 1960 (fig.51) and *Red Disk* 1960 (fig.52).

Leaving easel painting in order to produce collective art encouraged Miró to continue working on other murals (such as that commissioned by architect Walter Gropius for the Harvard Graduate Center)[42] as well as experimenting with new artistic media and materials. From the mid-1940s, he began making sculptures, such as the well-known *Moon Bird* (fig.49) and *Sun Bird* (fig.50), produced between 1946 and 1949, whose 'superb spontaneity' was praised by the art critic David Sylvester, who defined them as 'masterpieces of Surrealism'.[43] In the 1950s, Miró collaborated with his friend Llorens Artigas on a vast production of ceramic works; together they made, for instance, the ceramic walls for the new UNESCO headquarters in Paris (fig.17), inaugurated in 1958 and for which Miró received the Guggenheim International Award.[44] He also made graphic illustrations for journals and books, such as Michel Leiris's 1956 collection of poems *Bagatelles végétales* and the 1958 edition of Paul Eluard's *A toute épreuve* (fig.18). For his printmaking oeuvre, in 1954 Miró was awarded the Grand Prize for Graphic Work at the Venice Biennale.[45]

Palma de Mallorca: the final years
Miró had always dreamed of possessing a large studio and this long-awaited aspiration became a reality in 1956, when he moved

La simplicité même écrire
Pour aujourd'hui la main est là.

to Palma de Mallorca and asked Sert to design it.[46] Miró was almost sixty-five years old and a new period of maturity – equally prolific – began in his career. In sculpture, he worked intensely between 1960 and 1964 on six monumental pieces for the foundation that Aimé Maeght, his new Parisian art dealer, was creating in Saint-Paul de Vence near Nice.[47] Spread throughout the museum's garden and built in collaboration with Artigas's workshop, using various materials such as painted ceramics, wrought iron, bronze or concrete, Miró called the majestic series Le Labyrinthe – of which L'Arch 1963 (fig.19) is an imposing example.

In painting, in the early 1960s Miró again took up the old idea of radically reducing the elements of composition to work only with colourful dots and lines on a monochromatic background.[48] By disregarding chiaroscuros or any kind of shadings, he was able to fully explore the possibilities of spatial displacements within a two-dimensional field. Because there was neither horizon line nor any indication of depth, movement could go on 'to infinity', as Miró

17. Francesc Català-Roca,
Joan Miró working on the UNESCO mural, 'Wall of the Moon', La Gallifa, 1956
Photographic Archive
F. Català-Roca, Col·legi d'Arquitectes de Catalunya

18. Joan Miró
Illustration for A toute épreuve by Paul Eluard
1947–58
Woodcut
34.4 × 21
Museum of Modern Art, New York

explained.[49] His 1961 triptych *Blue I, Blue II, Blue III* (fig.53) is a typical example of his new pursuits. The dynamism generated by black and red spots is due to the blue neutral field that these elements navigate. The joyful disposition of colour and form in *The Song of the Vowels* 1966 (fig.54) and *Figures and Birds Dancing against a Blue Sky: Sparks* 1968 (fig.55) also transmits astonishing and unrelenting vitality.

In 1966, with the organisation of a retrospective at the National Museum of Modern Art, Tokyo, Miró made his first trip to Japan. His encounter with this country made a strong impact on him. Back in Mallorca, he finished the triptych *Painting on White Background for the Cell of a Recluse* 1968 (fig.56), which borrowed from Japanese calligraphy and aesthetics in attaining maximum intensity with a minimum of means.

The 1970s witnessed the establishment of Joan Miró as a major international artist: he was awarded various prizes and his work was studied and exhibited in New York, London, Paris, Zurich, Barcelona and Rome.[50] This recognition prompted him to organise and protect his legacy with the establishment of two foundations in Spain, one in Barcelona and another in Palma. Despite the institutionalisation of his oeuvre and his growing official profile, Miró did not stop experimenting

19. Joan Miró
L'Arch 1963
Concrete
580 × 615 × 215
Le Labyrinthe, Fondation Maeght, Saint-Paul de Vence

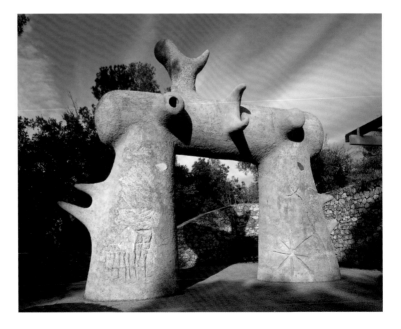

with new directions or working on projects of political content.

Formal experimentation is evident in the ephemeral action painting he made in 1969 for the exhibition *Miró Otro* (*Other Miró*) at the Association of Architects of Catalonia, Barcelona, where he painted a gigantic mural on the glass façade surrounding the building, which he voluntarily erased after the exhibition[51], and in his 1973 series of perforated and burnt canvases (fig.58). These latter works were dominated by an unusual violence. Miró's political commitment can be seen both in his heartfelt tribute to the protagonists of the May 1968 protests in France (fig.57) and in another triptych, *The Hope of a Condemned Man* 1974 (fig.59), completed same day of the execution by garrotte of the young Catalan anarchist Salvador Puig Antich. The visceral rejection that Miró had always felt for the Franco regime also materialised when he collaborated with the experimental theatre troupe La Claca on the staging of their play, *Mori el merma*,

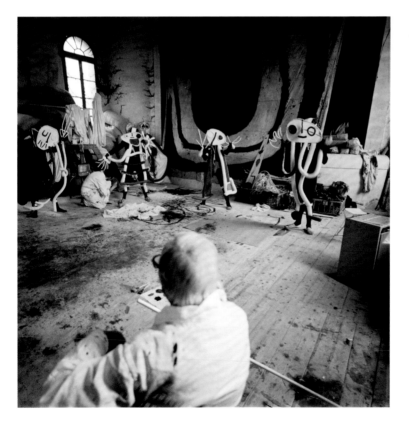

20. Francesc Català-Roca
*Joan Miró working on
'Mori el merma'*, Palma de
Mallorca, 1978
Photographic Archive
F. Català-Roca, Col·legi
d'Arquitectes de Catalunya

first performed in 1978. Miró, who designed puppets, masks and sets for the play (fig.20), actively participated in the satirical portrayal of the cruel 'merma' or bogeyman – an indirect reference to General Franco.

Coda

The last photographic portraits of Miró made in the early 1980s still register the vitality of the octogenarian artist. Unlike Picasso, Miró was able to witness the restitution of democratic rights in Spain after 1975. One of the goals of the foundations he established was to support new generations of artists, perhaps because, as he once affirmed, 'a painting might disappear, but the important thing for an artist is to stimulate the works of others with the example of his life'.[52]

Miró died in Palma on 25 December 1983 and was buried four days later in the Montjuïc cemetery in Barcelona. If his legacy still fascinates us today it is undoubtedly because of his ability to take full advantage of the paradoxes of his life and times. He was able to turn psychological and historical contradictions into a constant source of inspiration to produce works of art that are both deeply social and genuinely individual. As he once declared:

Anonymity allows me to renounce myself, but in renouncing myself I come to affirm myself even more. In the same way, silence is a denial of noise – but the smallest noise in the midst of silence becomes enormous.

The same process makes me look for the noise hidden in silence, the movement in immobility, life in inanimate things, the infinite in the finite, forms in a void, and myself in anonymity.

This is the negation of the negation that Marx spoke of. In negating the negation, we affirm.

In the same way, my painting can be considered humorous and even light hearted, even though I am tragic.[53]

21
Self-Portrait 1919
Oil on canvas
73 × 60
Musée Picasso, Paris

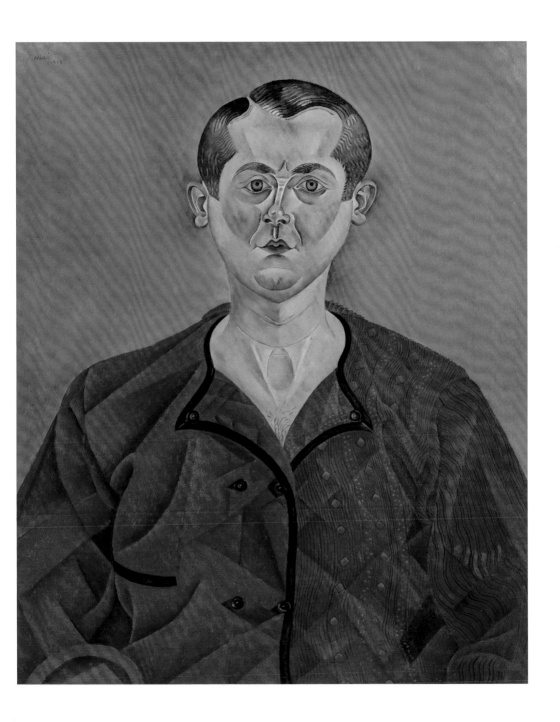

22
*Mont-roig, the Church and
the Village* 1919
Oil on canvas
73 × 60
Private collection, Spain

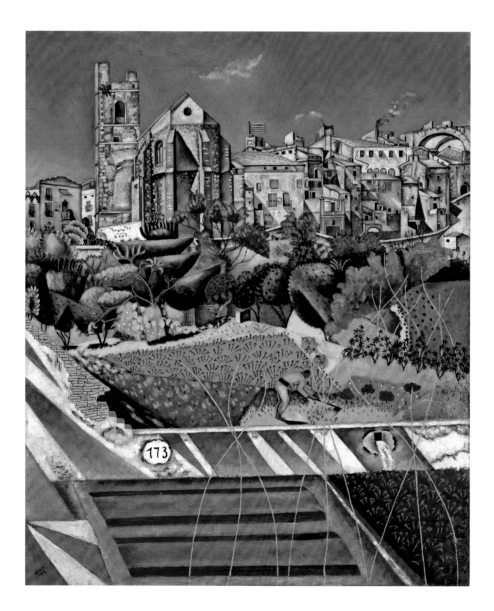

23
The Farm 1921–2
Oil on canvas
132 × 147
National Gallery of Art,
Washington DC

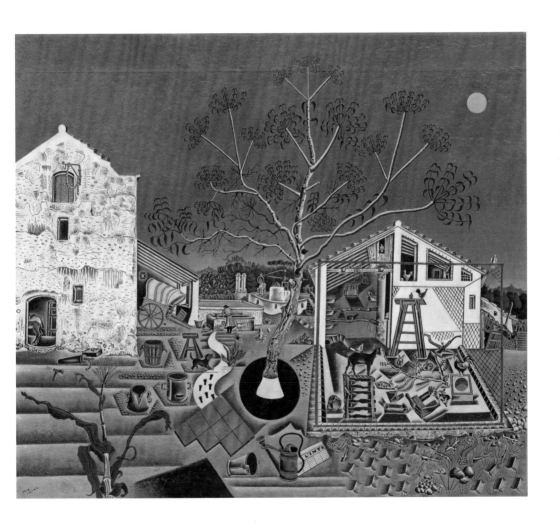

24
The Tilled Field 1923–4
Oil on canvas
66 × 92.7
Solomon R. Guggenheim
Museum, New York

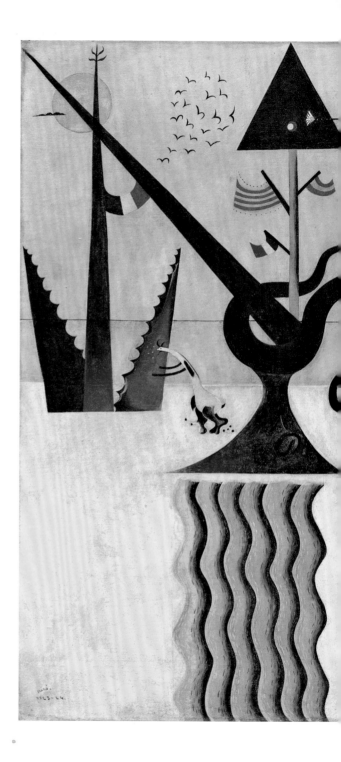

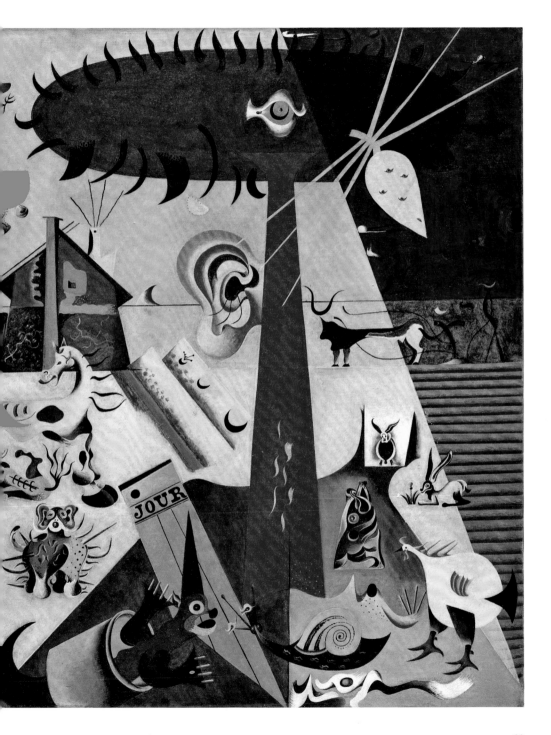

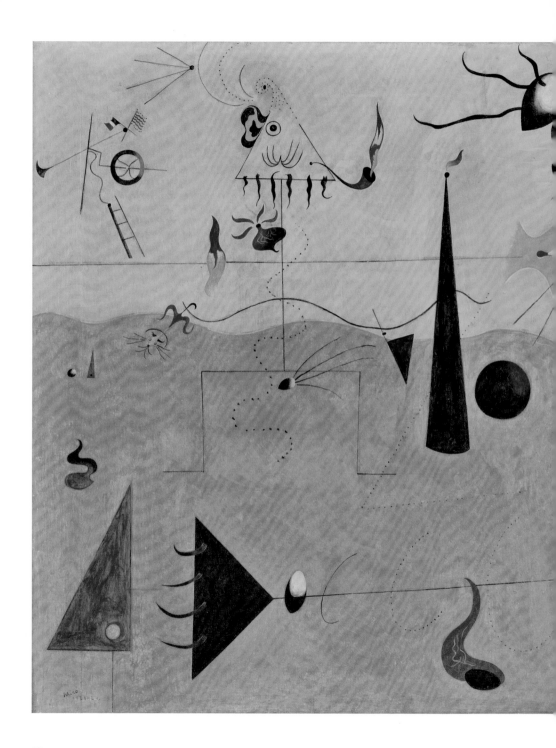

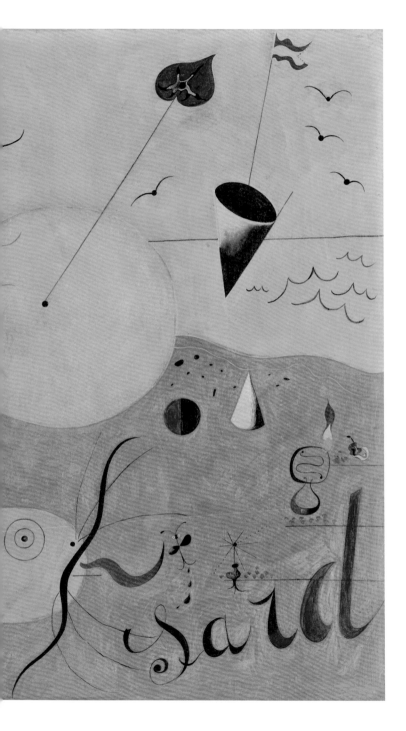

25
Catalan Landscape (The Hunter) 1923–4
Oil on canvas
64.8 × 100.3
Museum of Modern Art,
New York

26
Harlequin's Carnival
1924–5
Oil on canvas
66 × 93
Albright-Knox Art Gallery,
Buffalo

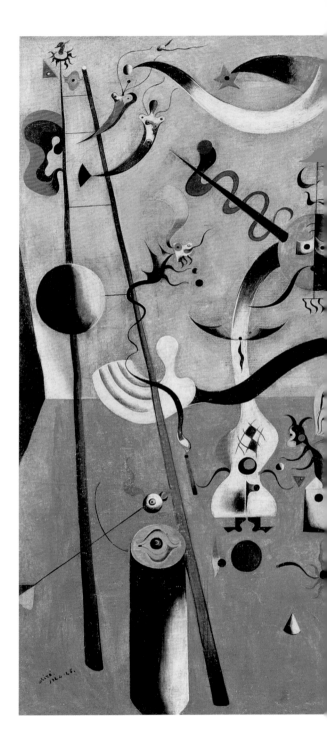

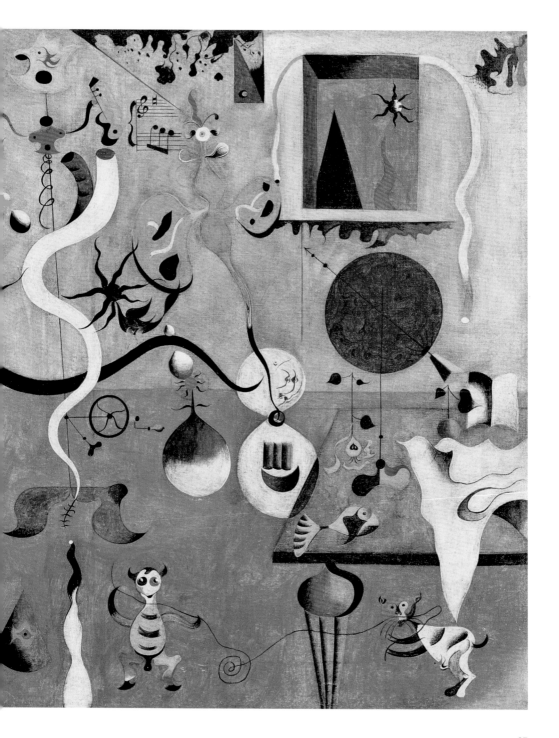

27
The Birth of the World 1925
Oil on canvas
250.8 × 200
Museum of Modern Art,
New York

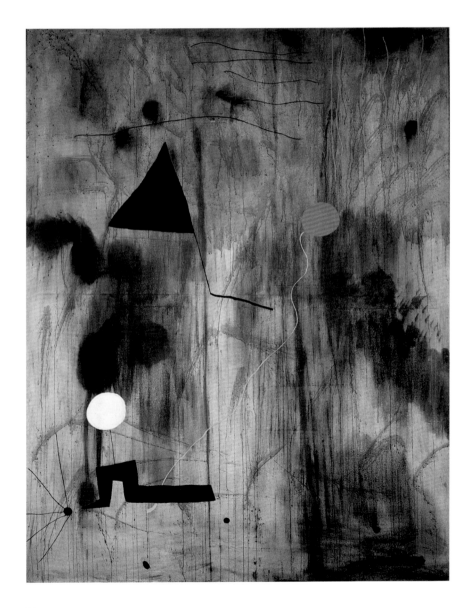

28
The Red Spot 1925
Oil and pastel on canvas
146 × 114
Museo Nacional Centro de
Arte Reina Sofia, Madrid

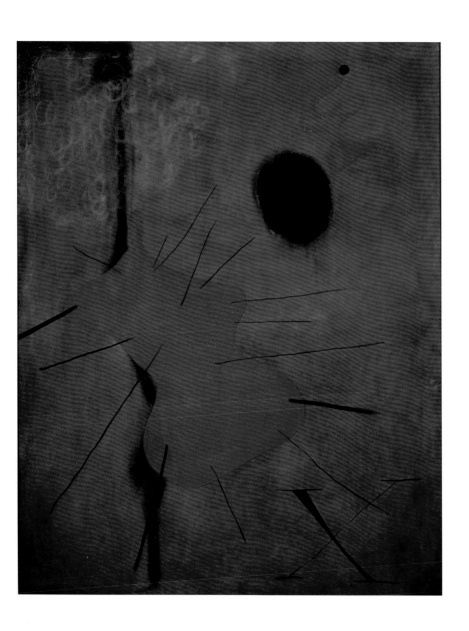

29
*The Happiness of Loving
my Brunette (Painting-
poem)* 1925
Oil on canvas
73 × 92
Private collection

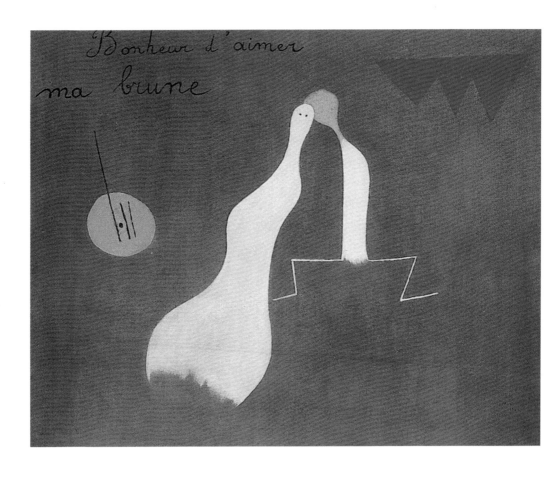

30
Painting 1927
Tempera and oil on canvas
97.2 × 130.2
Tate

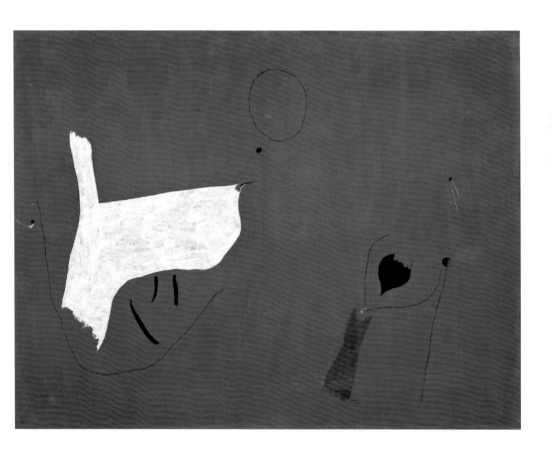

31
Person Throwing a Stone at a Bird 1926
Oil on canvas
73.7 × 92.1
Museum of Modern Art, New York

32
Hand Chasing a Bird 1926
Oil on canvas
93 × 73
Private collection

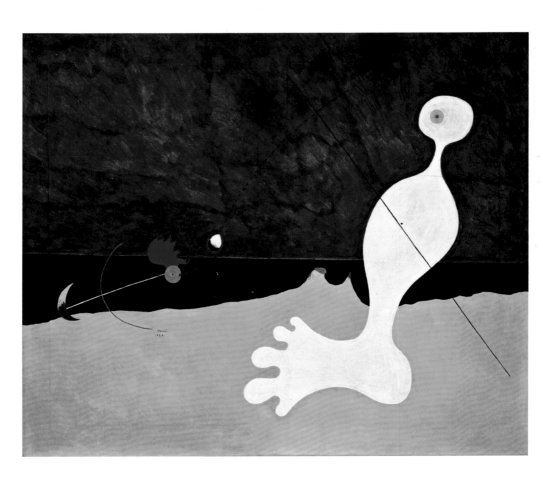

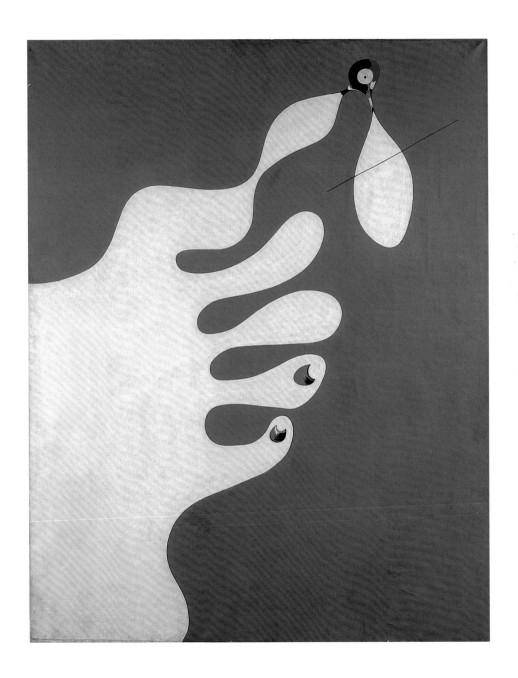

43

33
*Photo: ceci est la couleur
de mes rêves* 1925
Oil on canvas
96.5 × 129.5
Metropolitan Museum of
Art, New York

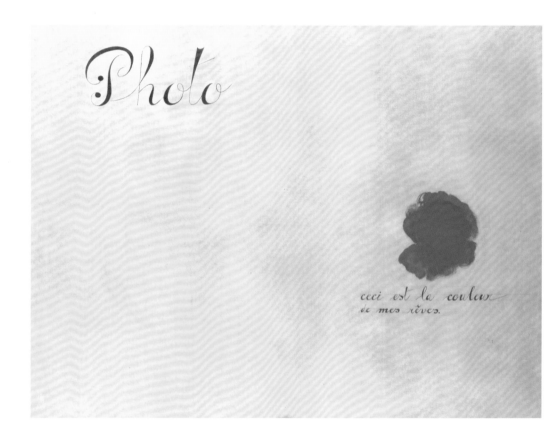

34
*Un Oiseau poursuit une
abeille et la baisse* 1927
Oil, aqueous medium and
feathers on canvas
83.5 × 102.2
Private collection

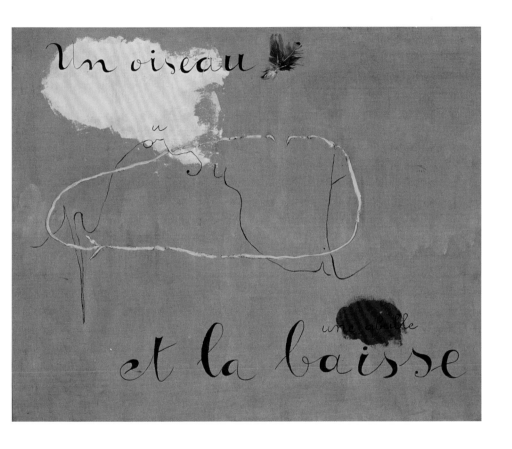

35
*Painting (The Magic
of Colour)* 1930
Oil on canvas
150.2 × 225.1
The Menil Collection,
Houston

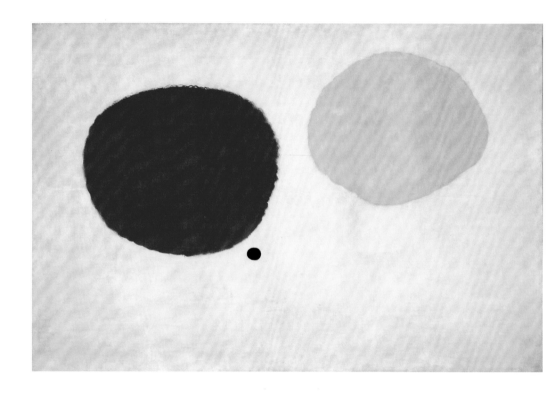

36
Portrait of a Dancer 1928
Feather, cork and hat-pin
on canvas
100 × 80
Musée national d'art
moderne, Centre Georges
Pompidou, Paris

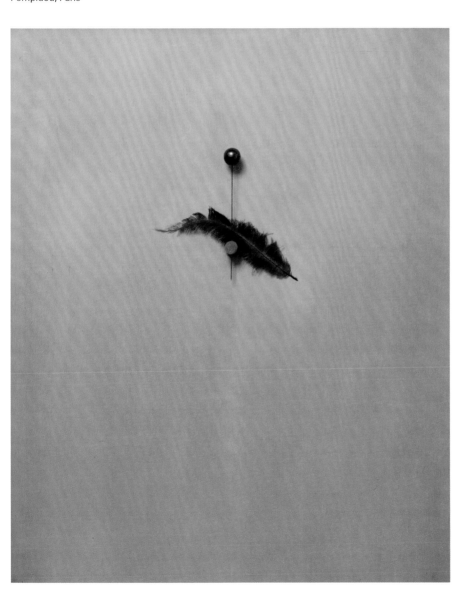

37
Construction 1930
Oil on wood and metal on
wood panel
91 × 71 × 37
Staatsgalerie Stuttgart

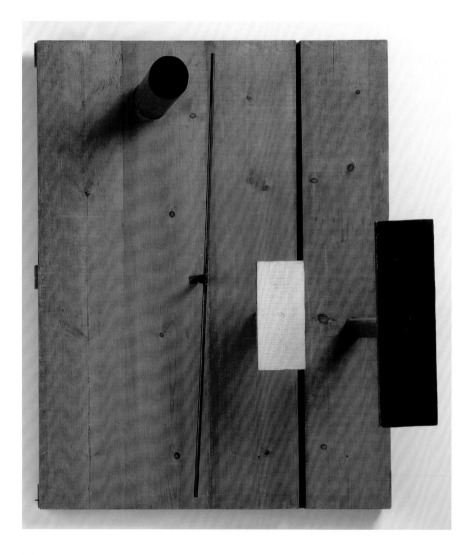

38
Relief Construction 1930
Oil on wood, nails, staples,
and metal on wood panel
91.1 × 70.2 × 16.2
Museum of Modern Art,
New York

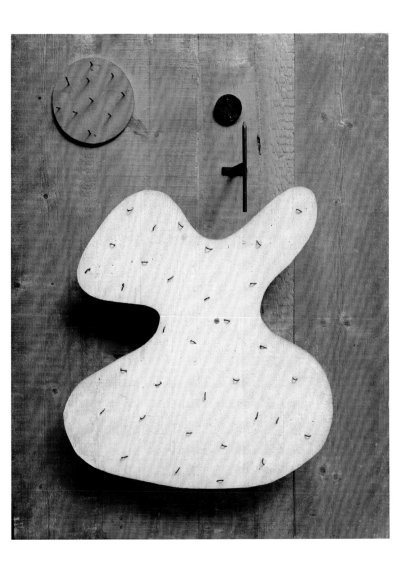

39
Aidez l'Espagne (Help Spain) 1937
Stencil published in the *Cahiers d'art*
24.8 × 19.4
Museum of Modern Art, New York

40
Rope and People, I 1935
Oil on cardboard mounted on wood, with coil of rope
104.8 × 74.6
Museum of Modern Art, New York

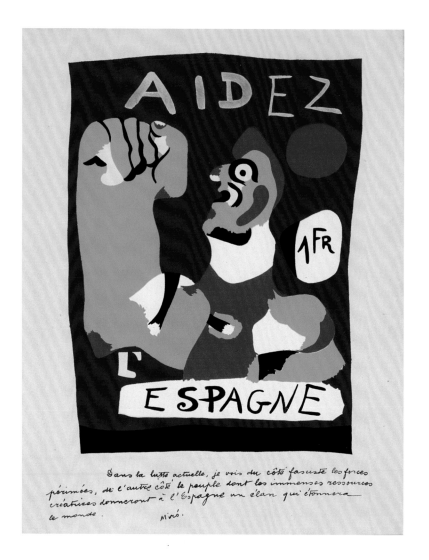

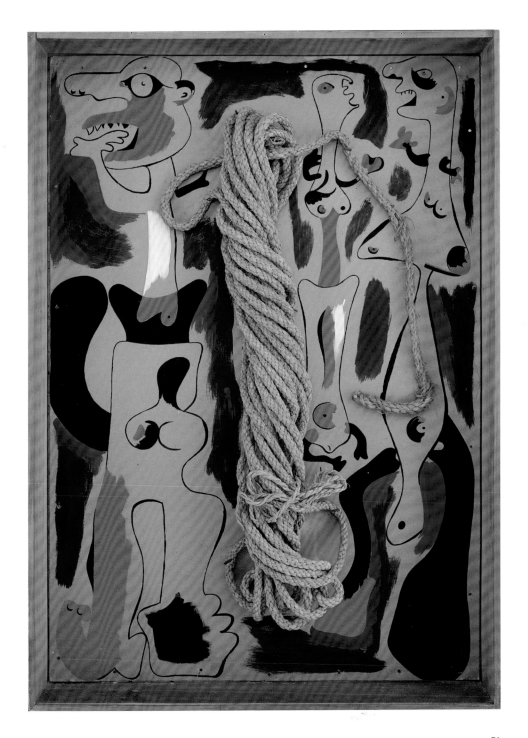

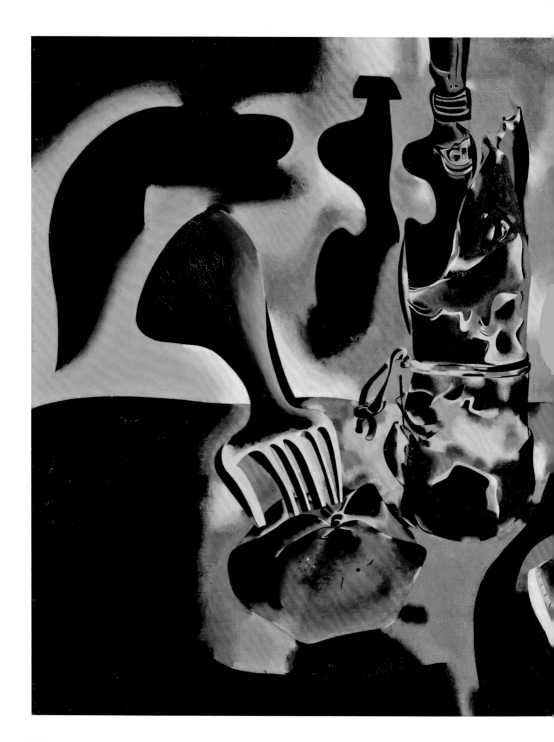

41
Still Life with Old Shoe
1937
Oil on canvas
81.3 × 116.8
Museum of Modern Art,
New York

42
Self-Portrait 1937–8
Pencil, crayon and oil
on canvas
146.1 × 97.2
Museum of Modern Art,
New York

43
Head of a Woman 1938
Oil on canvas
46 × 55
Minneapolis Institute
of Arts

44
The Rooster 1940
Gouache, watercolour and
pencil on paper
63.5 × 48.9
Private collection

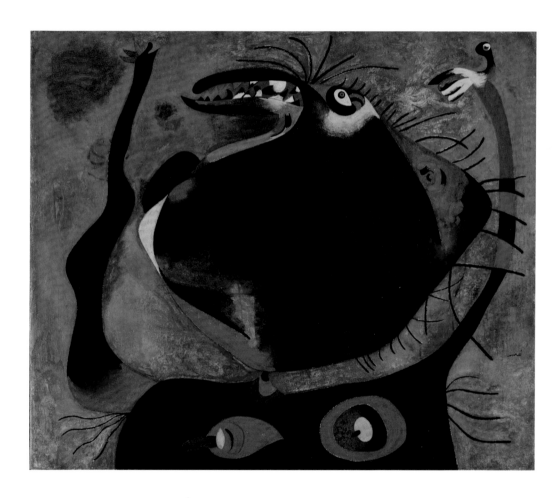

45
Nocturne 1940
Gouache and oil wash
on paper
38 × 46
Private collection

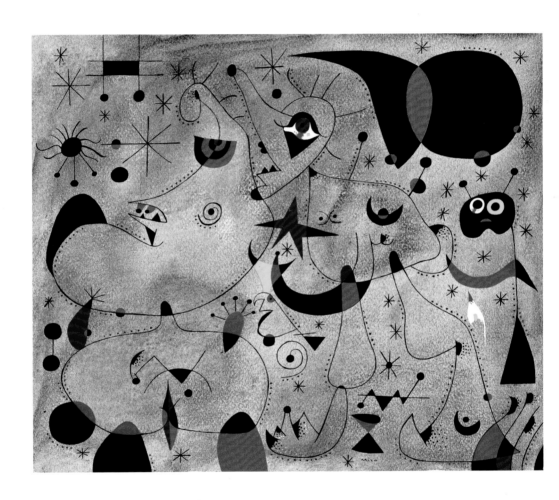

46
Woman in the Night 1940
Gouache and oil wash
on paper
46 × 38
Collection Martin Z.
Margulies

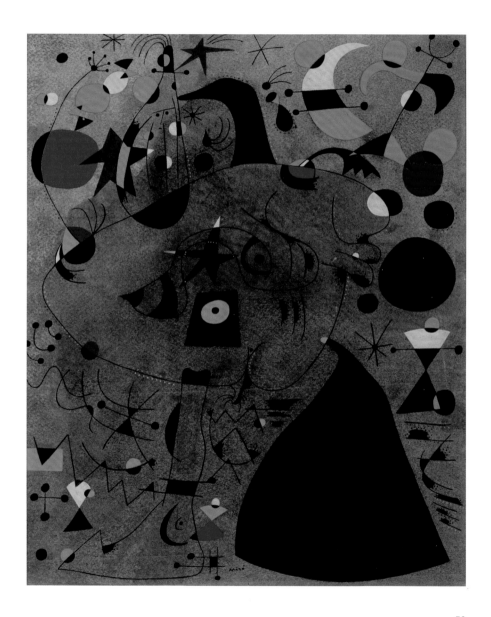

47
*Woman Dreaming of
Escape* 1945
Oil on canvas
130.2 × 162.5
Fundació Joan Miró,
Barcelona

48
*Mural for the Terrace Plaza
Hotel, Cincinnati* 1947
Oil on canvas
259 × 935
Cincinnati Art Museum

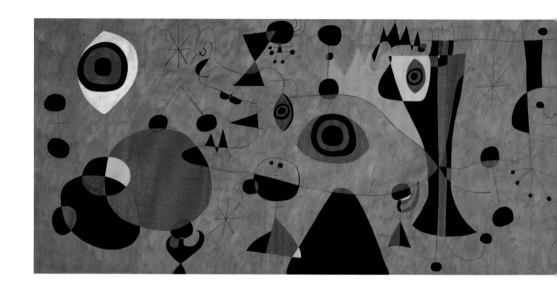

49
Moon Bird 1946–9
Bronze
19 × 17 × 12.5
Fundació Joan Miró,
Barcelona

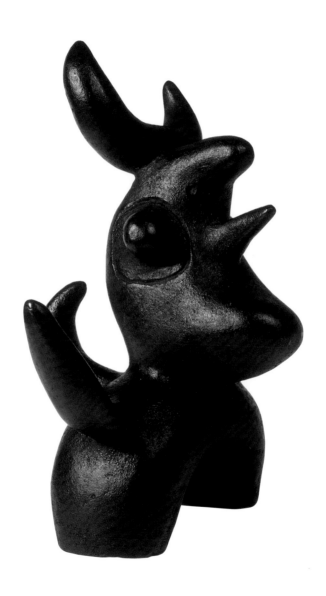

50
Sun Bird 1946–9
Bronze
13.5 × 11 × 18.5
Fundació Joan Miró,
Barcelona

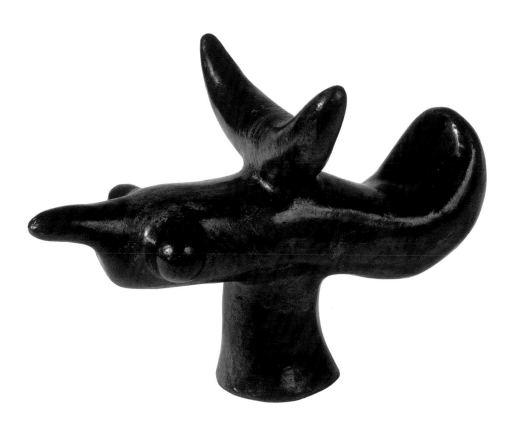

51
Solitude II 1960
Oil and charcoal on
cardboard
75 × 105
Private collection

52
Red Disk 1960
Oil on canvas
130 × 161
New Orleans Museum
of Art

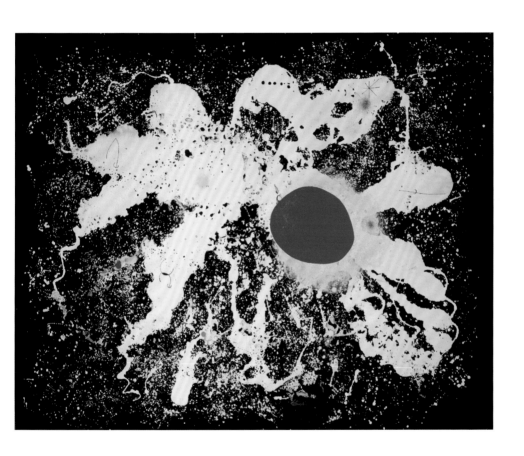

53
Blue I, Blue II, Blue III 1961
Oil on canvas
Three panels, each
270 × 355
Musée national d'art
moderne, Centre Georges
Pompidou, Paris

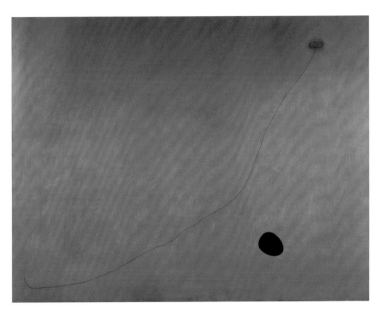

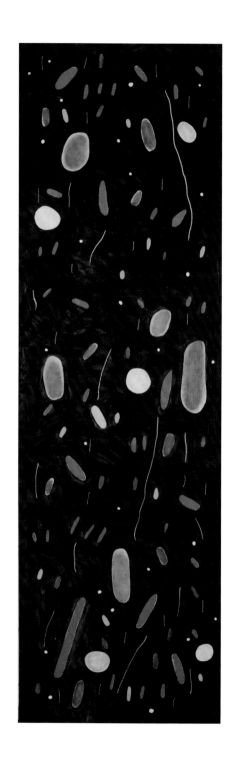

54
The Song of the Vowels
1966
Oil on canvas
366 × 114.8
Museum of Modern Art,
New York

55
*Figures and Birds Dancing
against a Blue Sky: Sparks*
1968
Oil on canvas
173.6 × 291.6
Musée national d'art
moderne, Centre Georges
Pompidou, Paris

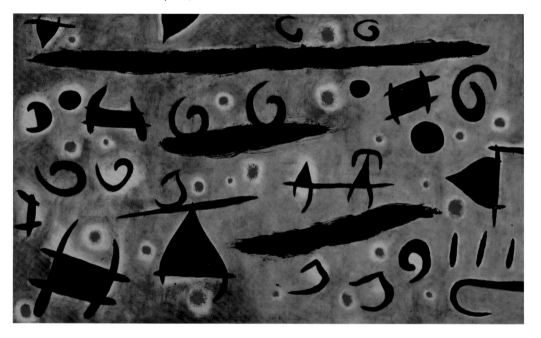

56
*Painting on White Background
for the Cell of a Recluse* 1968
Acrylic on canvas
Three panels, each
268 × 352
Fundació Joan Miró,
Barcelona

57
May 68 1968–73
Acrylic on canvas
200 × 200
Fundació Joan Miró,
Barcelona

58
Burnt Canvas I 1973
Acrylic on canvas, later
perforated and burnt
130 × 194.6
Fundació Joan Miró,
Barcelona

59
*The Hope of a Condemned
Man* 1974
Acrylic on canvas
Three panels, each
271.5 × 355.5
Fundació Joan Miró,
Barcelona

Notes

1. Interviewed by Pierre Bourcier, 8 Aug. 1968, in Margit Rowell (ed.), *Joan Miró: Selected Writings and Interviews*, London 1987, p.275.

2. Jacques Dupin, *Miró*, New York and Barcelona 1993, p.9.

3. Letter to Dupin, 9 Oct. 1957, in Rowell 1987, p.45.

4. For more information about Miró's early career, see Robert S. Lubar, 'Miró before *The Farm*', in *Joan Miró: A Retrospective*, exh. cat., Guggenheim Museum, New York 1987, pp.10–28. See also Jacques Dupin and Ariane Lelong-Mainaud (eds.), *Miró: Paintings*, cat. raisonné, 6 vols., Barcelona and Paris 1999–2004.

5. Letter to José F. Ràfols, 11 Aug. 1918, in Rowell 1987, p.57. The first volume of Miró's correspondence has been published as Josep Ainaud de Lasarte et al (eds.), *Epistolari català. 1911–1945*, Barcelona 2009.

6. Letter to Enric Ricart, 14 Sept. 1919, in Dupin 1993, p.75.

7. Letter to Ràfols, 8 May 1920, in Rowell 1987, p.72.

8. Victoria Combalia describes Miró's decision to spend half of his time in Paris as an 'intelligent campaign of promotion', in 'Miró's strategies', in Sylvia Martin and Stephan von Wiese (eds.), *Joan Miró*, Munich 2008, p.44. Note that Miró's periods in Catalonia were strictly creative: after his failed 1918 Barcelona show, he did not have a solo exhibition there until 1949.

9. Joan Miró, 'Memories of the Rue Blomet' (1977), in Rowell 1987, p.100.

10. Exhibited one day only at a restaurant in Montparnasse in 1922, *The Farm* was later purchased by Miró's friend Ernest Hemingway, as he explained in *The Farm*, exh. cat., Pierre Matisse Gallery, New York 1933, unpag.

11. Both terms were used by Miró in his conversations with Roland Penrose for the 1978 documentary *Miró: Theatre of dreams*. See also *Joan Miró: Magnetic Fields*, exh. cat., Guggenheim Museum, New York 1972.

12. Miró, 'Memories of the Rue Blomet', in Rowell 1987, p.103.

13. As Carolyn Lanchner has recently pointed out, 'Miró's space, a prime example to Abstract Expressionists and countless others, has now become so common that it is often forgotten how radical it once seemed', in C. Lanchner, *Joan Miró*, New York 2008, p.15.

14. Letter to Ràfols, 7 Oct. 1923, in Rowell 1987, p.83; emphasis mine. Note that in 1917 a farsighted Miró had already affirmed that a new style would develop after Fauvism, Cubism and Futurism: 'After all that, we will see a free Art in which the "importance" will be in the resonant vibration of the creative spirit' (letter to Ricart, 1 Oct. [1917], in Rowell 1987, p.52).

15. Miró later declared that he 'attended the Surrealist meetings very faithfully' although he 'was usually silent', in 'Memories of the Rue Blomet', in Rowell 1987, p.102.

16. Dupin, *Joan Miró*, Barcelona 2009, p.50.

17. Interviewed by Denys Chevalier, Nov. 1962, in Rowell 1987, p.264.

18. Andre Breton, *Manifestoes of Surrealism*, Ann Arbor 1969, p.15.

19. Interviewed by Georges Duthuit, May 1937, in Rowell 1987, pp.151–2. Throughout his career, Miró kept rejecting all kinds of esoteric formalisms: 'For me form is never something abstract; it is always a man, a bird, or something else. For me, painting is never form for form's sake', interviewed by James Johnson Sweeney, Feb. 1948, in Rowell 1987, p.207.

20. A. Breton, *Le surrealisme et la peinture*, revised ed., New York 1945, p.68. Breton acquired Miró's *The Hunter (Catalan Landscape)* in June 1925.

21. Dupin 2009, p.7.

22. Those who accused Miró of painting without premeditation usually forgot that the artist made many sketch drawings for his paintings; see Gaeton Picon (ed.), *Joan Miró: Catalan notebooks*, New York 1977.

23. The production was choreographed by George Balanchine and Bronislav Nijinska, and set to music by Constance Lambert.

24. See 'The Correspondence of Alexander Calder and Joan Miró', in Elizabeth Hutton Turner and Oliver Wick (eds.), *Calder, Miró*, exh. cat., Fondation Beyeler, Basel 2004, pp.257–75.

25. Interviewed by Yvon Taillandier, Feb. 1959, in Rowell 1987, p.251.

26. Sentence attributed to Miró by Maurice Raynal in his *Anthologie de la peinture en France de 1906 a nos jours*, Paris 1927, p.34. Years later, Miró said: 'Antipainting was a revolt against a state of mind and traditional painting techniques that were later judged morally injustifiable. It was also an attempt to express myself through the materials: bark, textile fiber, assemblage of objects, collages, and so on', interviewed by Chevalier 1962, in Rowell 1987, p.266.

27. See Jim Coddington, 'The language of materials', in Anne Umland (ed.), *Joan Miró: Painting and Anti-painting, 1927–1937*, New York 2008, pp.17–27.

28. Umland 2008, p.4.

29. Letter to Pierre Matisse, 12 Jan. 1937, in Rowell 1987, p.146.

30. Letter to Matisse, 12 Feb. 1937, in Rowell 1987, p.147.

31. Interviewed by Lluis Permanyer, April 1978, in Rowell 1987, p.293.

32. Unlike Picasso or Buñuel, Miró was never a member of the Communist Party. As his wife once declared, 'Joan hated the dictatorship. He was always an antifascist, but he never wanted [to] be linked to any party', interviewed by Victoria Combalía, *Picasso-Miró. Miradas cruzadas*, Madrid 1998, p.104.

33. See Catherine Blanton Freedberg, *The Spanish Pavilion at the Paris World's Fair*, 2 vols., New York 1986.

34. After its deinstallation, the mural travelled to Valencia and there it disappeared during the chaos of the war.

35. Letter to Matisse, 4 Feb. 1940, in Rowell 1987, p.168. On the importance of sexual exuberance in Miró's work, see Robert Motherwell's statements in the 1988 film *La realidad inventada: Joan Miró*.

36. Heidi Irmer, 'The Barcelona Series', in Martin and von Wiese 2008, p.88.

37. Clement Greenberg, *Joan Miró*, New York 1948, p.42.

38. Shuzo Takiguchi, *Miró*, Tokyo 1940, and J. Johnson Sweeney, *Joan Miró*, New York 1941.

39. Josep Lluis Sert, 'Joan Miró. Painting for vast spaces' (1961), in Patricia Juncosa Vecchierini (ed.), *Miró, Sert: correspondencia, 1937–1980*, Murcia and Barcelona 2008, p.614.

40. Letter to J.L. Sert, 19 Nov. 1947, in Vecchierini 2008, p.93.

41. Radio interview by Georges Charbonnier, Jan. 1951, in Rowell 1987, pp.217 and 219.

42. See the letters from Walter Gropius to Miró, dated 5 and 28 July 1950, in Vecchierini 2008, p.526–33.

Index

43. David Sylvester, 'Fowl of Venus' (1967), in *About Modern Art: Critical Essays 1948–2000*, revised ed., London 2002, p.19 See also Emilio Fernández Miró and Pila Ortega Chapel (eds.), *Joan Miró: Sculptures (1928–1982)*, cat. raisonné, Barcelona and Paris 2006.

44. See Joan Punyet Miró and Joan Gardy Artigas (eds.), *Miró, Artigas: Ceramics (1941–1981)*, cat. raisonné, Barcelona and Paris 2007.

45. See Patrick Cramer (ed.), *Joan Miró. Catalogue raisonné des livres illustrés*, Geneva 1989.

46. In his 1938 text 'I dream of a large studio', Miró had written: 'I would like to try my hand at sculpture, pottery, engraving, and have a press, … and to bring myself closer, through painting, to the human masses I have never stopped thinking about', in Rowell 1987, p.162.

47. See letter from Aimé Maeght to Miró, n.d. [1960], in Vecchierini 2008, pp.548–51.

48. In 1924 Miró had already written: 'There is no doubt that my canvases that are simply drawn, with a few dots of color, a rainbow, are more profoundly moving' (letter to Michel Leiris, 10 Aug. 1924, in Rowell 1987, p.86).

49. Interviewed by Taillandier, Feb. 1959, in Rowell 1987, p.251.

50. Miró was awarded the Grand Prize for Painting from the Carnegie Foundation in 1967 and Spain's Gold Metal for Fine Arts in 1980. For a bibliographical list of books on Miró since the 1950s, see Dupin 2009, pp.94–95.

51. The work can be seen in the experimental film *Miró l'altre* directed by Pere Portabella in 1969.

52. Quoted in Antoni Tàpies, 'La enseñanza de Joan Miró', in *La realidad como arte*, Murcia 1989, p.247.

53. Interviewed by Taillandier, Feb. 1959, in Rowell 1987, p.253.

First published 2011 by order of the Tate Trustees
by Tate Publishing, a division of Tate Enterprises
Ltd, Millbank, London SW1P 4RG
www.tate.org.uk/publishing

Reprinted 2011

A catalogue record for this book is available from
the British Library

ISBN 978 1 85437 941 2

Distributed in the United States and Canada by
ABRAMS, New York

Library of Congress Control Number: 2010940868

Designed by Anne Odling-Smee, O-SB Design
Colour reproduction by DL Interactive Ltd, London
Printed in Italy by Conti Tipicolor, Florence

Front cover: Joan Miró, *Hand Chasing a Bird*
1926 (detail of fig.32)
Frontispiece: Joan Miró, *Woman Dreaming of
Escape* 1945 (detail of fig.47)

Measurements of artworks are given in
centimetres, height before width.

Photo credits

All images copyright the
owner of the work unless
otherwise stated below

© akg-images fig.29
© Jaume Blassi frontispiece,
figs.11, 12, 47, 49, 50, 56, 59,
© Boltin Picture/Bridgeman Art
Library fig.34
Private Collection/Photo ©
Christie's Images/The Bridgeman
Art Library fig.44
© Private Collection/Bridgeman Art
Library fig.51
© Calder Foundation New York/Art
Resource, NY fig.13
© Cincinnati Art Museum figs.16, 48
© Photographic Archive F. Català-
Roca - Arxiu Fotogràfic de l'Arxiu
Històric del Col·legi d'Arquitectes
de Catalunya figs.1, 15, 17, 20
© Peter Harholdt fig.46
© Hickey-Robertson, Houston fig.35
© Archives Fondation Marguerite et
Aimé Maeght, Saint-Paul (France)
Photo: Claude Germain fig.19
© Man Ray Trust/ADAGP – DACS/
Telimage – 2010 fig.6
RMN
 © RMN / Jean-Gilles Berizzi fig.21
 © Collection Centre Pompidou,
 Dist. RMN / Droits reserves fig.55
 © Collection Centre Pompidou,
 Dist.RMN / Philippe Migeat
 figs.36, 53
Scala, Florence
 © Albright Knox Art Gallery/Art
 Resource/Scala, Florence fig.26
 © 2010 Image copyright The
 Metropolitan Museum of Art/Art
 Resource/Scala, Florence fig.33
 © 2010 digital image, The Museum
 of Modern Art, New York/ Scala,
 Florence figs.2, 4, 7, 9, 18, 25, 27,
 31, 38–42, 54
© Successio Miro, 2010 fig.22

Copyright credits

Joan Miró: © Succession Miró/
ADAGP, Paris and DACS, London
2011

Man Ray: © Man Ray Trust/ADAGP,
Paris and DACS, London 2011